THE VISITORS

THE VISITORS

BY CHARLOTTE CORY

FIRST PUBLISHED IN THE UNITED KINGDOM IN 2007 BY
DEWI LEWIS PUBLISHING
8 BROOMFIELD ROAD, HEATON MOOR
STOCKPORT SK4 4ND, ENGLAND

WWW.DEWILEWISPUBLISHING.COM

THE RIGHT OF CHARLOTTE CORY TO BE IDENTIFIED AS AUTHOR OF
THIS WORK HAS BEEN ASSERTED BY HER IN ACCORDANCE WITH THE
COPYRIGHT, DESIGNS AND PATENTS ACT 1988

ISBN: 978-1-904587-50-7

DESIGN AND LAYOUT: CAROLINE WARHURST
PRINT: EBS, VERONA, ITALY

Rollup, Rollup

SEE FOR YOURSELF

THE VISITORS

BY CHARLOTTE CORY

AN ASTONISHING
SIDE-SHOW OF PHOTOGRAPHS

All Clichés Conserved

A CIRCUS OF LIGHT
MAGICAL TRANSFORMATIONS FROM
THE PHOTOGRAPHER'S TENT

DEWI LEWIS PUBLISHING

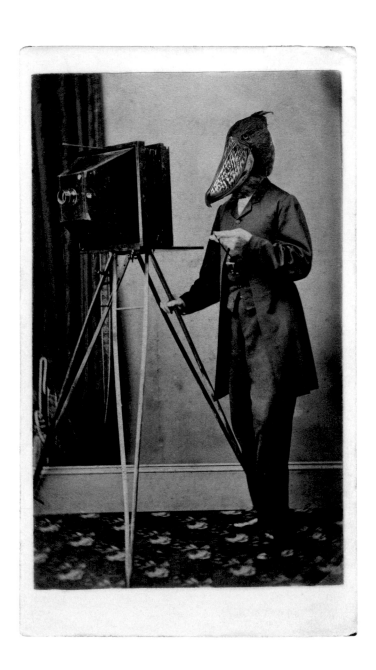

ALL CLICHÉS CONSERVED

Cartes de visite, photographic visiting cards, were a Victorian craze. As cartomania caught on and the price of photography spiralled downwards, everyone from Queen Victoria to the lowest scullery maid had their picture taken. Again and again as if they couldn't quite believe what they looked like. They all then acquired fancy albums to put their photographs in – and these albums, of course, needed filling. It was pyramid selling at its most explosive. Portrait clubs were formed. Agents were appointed. Card parties, in the form of cdv swap meets, were held (these events were not unlike Tuppaware parties of the 1960s or girlie Ann Summers parties today). Sitters were encouraged to order an extra dozen copies of their favourite pose to give to friends and family, placing each recipient under an obligation to return the favour. Every portrait taken thus generated up to a dozen fresh orders for photographs, and also for albums which also then needed filling…

Many millions of these cartes were produced and are now so commonplace, and discarded in junk shops, that they are almost worthless. Can there be anything more poignant than a person got up in their best bib and tucker, preserved for a posterity that is no longer interested? The fading sepia image invariably made sorrier, and more sepia, by the magniloquent claims of the photographer printed proudly on the back – often in French to enhance the aura of artistry: "Les clichés sont conservés"; "Negatives are always kept"; "Copies may always be had". And how, I ask as I peer into the picture – (who were they? why did they choose this hat, that brooch? Look at the swirling carpet, the drooping drapery, the exuberantly painted but buckling backdrop) – how, exactly, may copies always be had? What hubris on the part of the

photographer. And what preposterous optimism the subject displays, standing with hand on hip, nose in the air, staring confidently into the lens: this is how I will be seen; this is how the unknown future will remember me! But, where are all the clichés now? Many of the artist photographers (as they often pleased to style themselves) went bankrupt and died in penury when the craze for their art cartes faded and their lucrative means of livelihood dissolved into the shadows they had endeavoured so hard to secure.

Yet there is something assuredly sadder than discarded photographs of forgotten faces and blurry family pets who would not keep still in the excitement of visiting the studio: all those stuffed animals in museums, shot long ago not on glass plates but with guns, their very bodies preserved for posterity to gawk at. Where did this moth-eaten lion sniff his last antelope? Over what distant verdure did that dusty parrot flap tremulous emerald wings? How many of us have stood with our noses pressed to the glass eyeing these captured creatures. I think of Alfred the gorilla in Bristol Museum whom I have known all my life, whom my long dead grandmother often took me to visit. The birds in the natural history museum in Nairobi, in the Prince of Wales Museum in Bombay, The Horniman Museum in South London. Sad dignified specimens I visit whenever I can, greeting them like old friends. The polar bear at Tring. Ah yes, the polar bear. Each time I see him I am older. He is still the same. If anything (he is so well looked after by the Tring branch of the Natural History Museum) he looks more spry and spruce with the passing years. Long after I am gone these creatures will gaze with their glass eyes from their glass cases. What do they see?

It is a strange fact of history that cartomania took off in exactly the same year, 1859, that Charles Darwin published *The Origin of Species.*

The first generation of people to be photographed were also the first generation of people to realize that they were closely related to the animals. In losing their sense of immortality and godlike status they found themselves immortalized by photography. "What kind of an animal am I?" had long been a popular Victorian parlour game. Now they played it for real. Subjects gazed into their own unfamiliar picture in the uncomfortable knowledge that we are all indeed animals. Even today when you can hardly walk anywhere without being photographed, when legal notices warn you that your every move is being recorded on cctv for your own good, we still stare in disbelief at our own image. Is this what I really look like? Can this truly be me? Who, indeed, am I? It is still a good question.

Charlotte Cory
2007

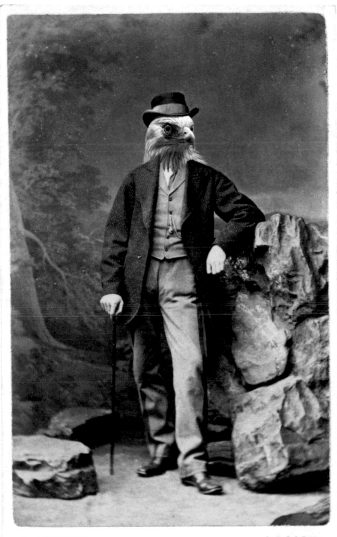

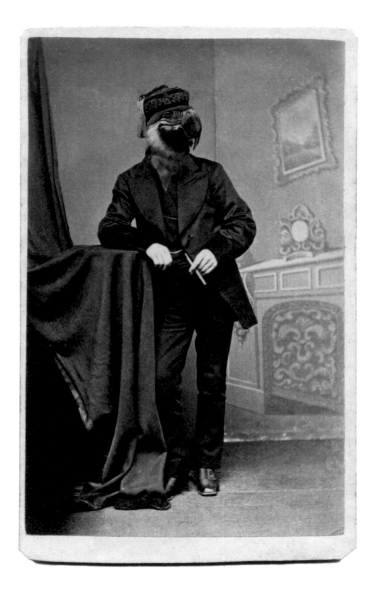

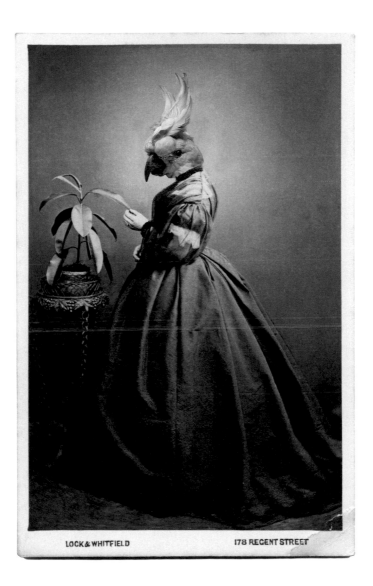

LOCK & WHITFIELD 178 REGENT STREET

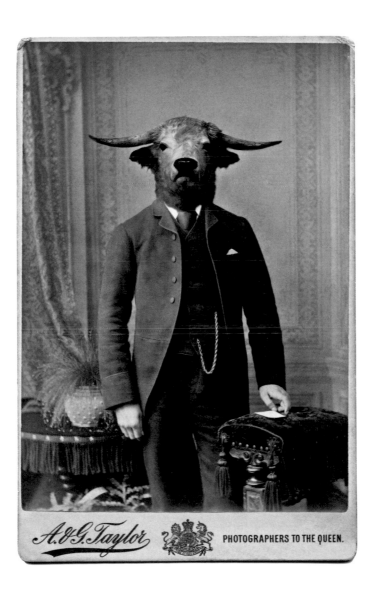

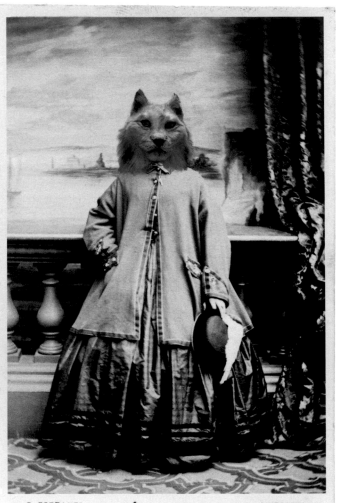

C. FERRANTI. *Miss Harding* LIVERPOOL

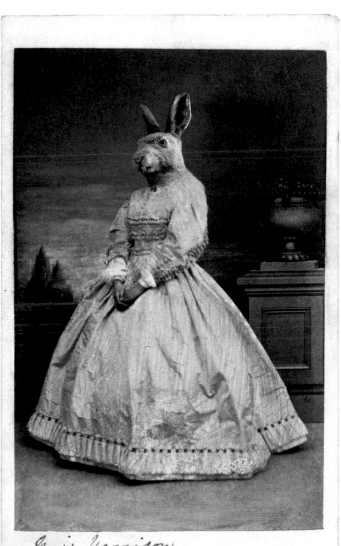

Miss Harrison.

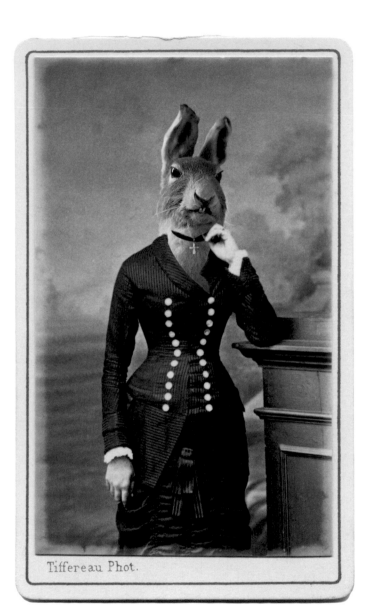

Tiffereau Phot.

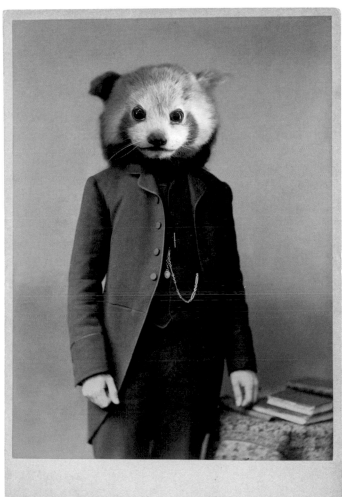

H.P. ROBINSON TUNBRIDGE WELLS

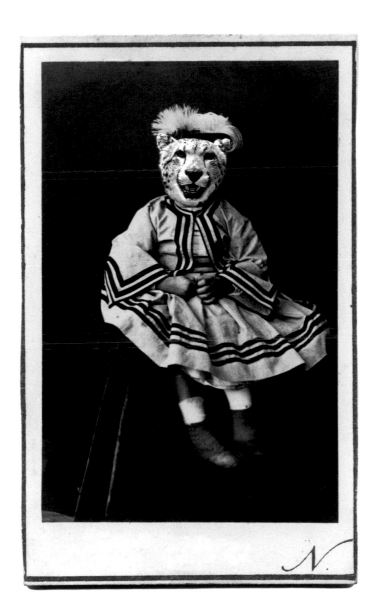

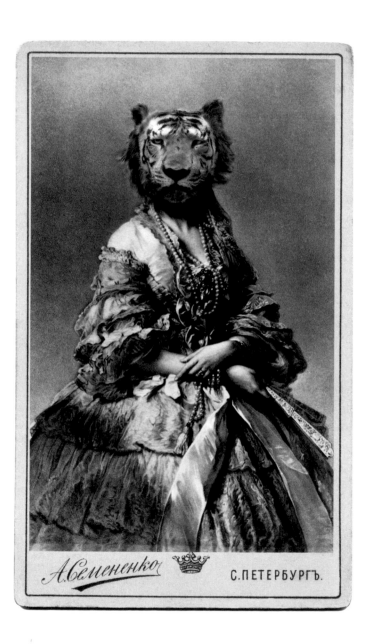

А. Семененко С.ПЕТЕРБУРГЪ.

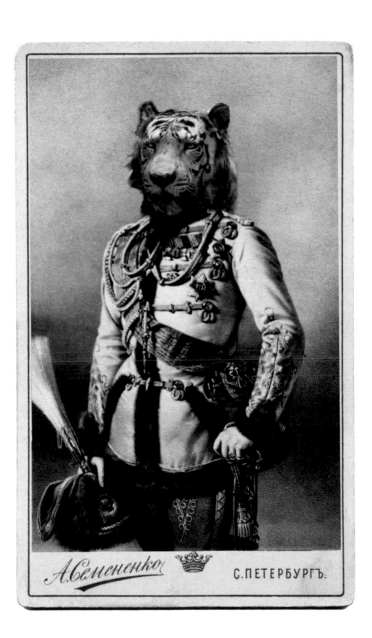

А. Семененко С. ПЕТЕРБУРГЪ.

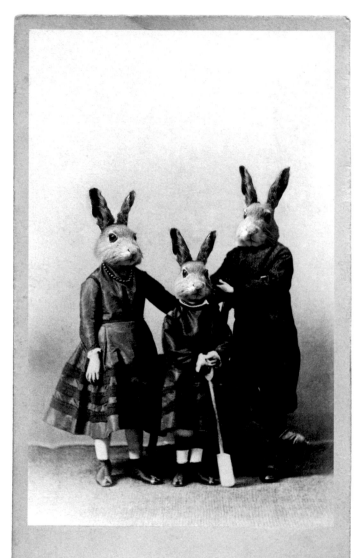

HENNAH & KENT. BRIGHTON

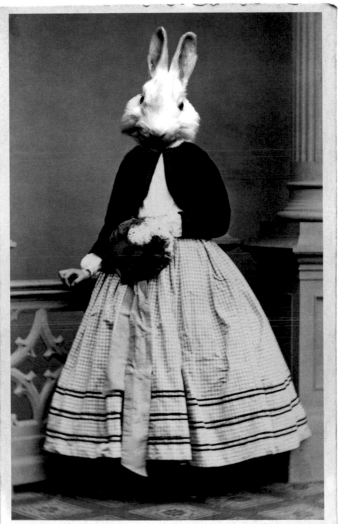

L.Powers Florence

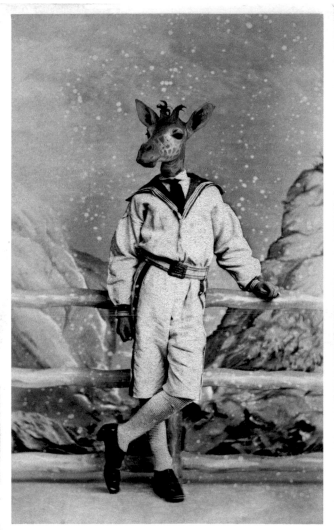

W.T. & R.GOWLAND, YORK

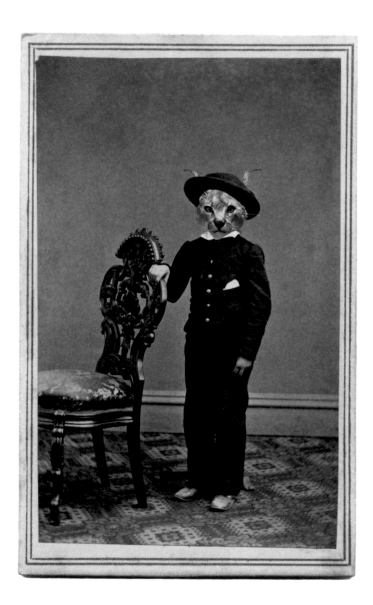

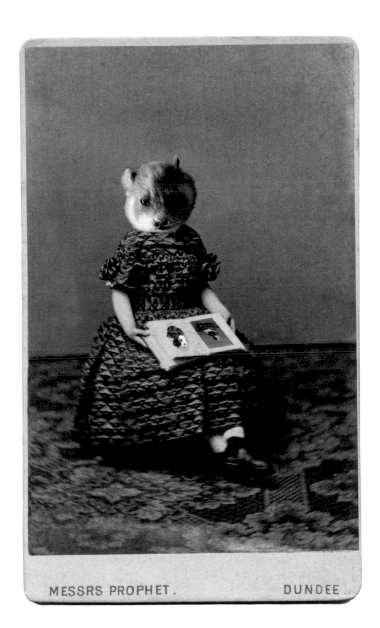

MESSRS PROPHET. DUNDEE

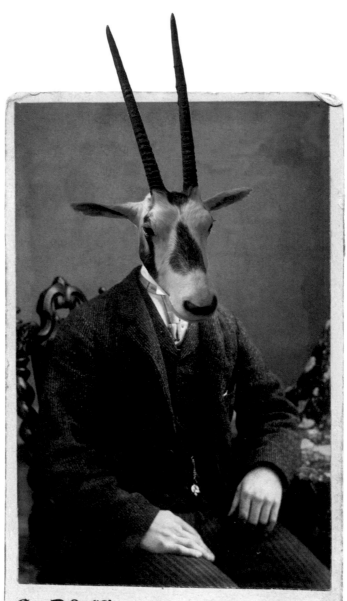

S. Abell's, THREE FOR A SHILLING.

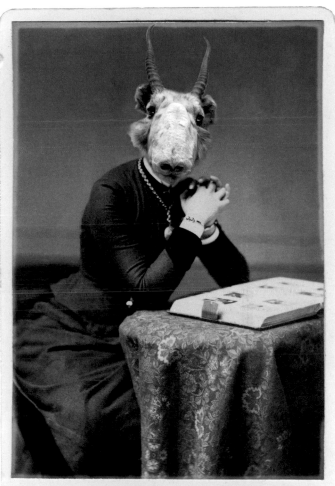

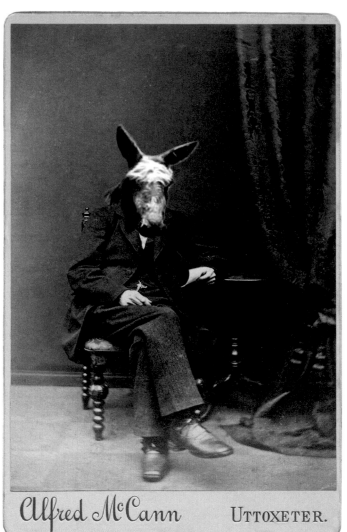

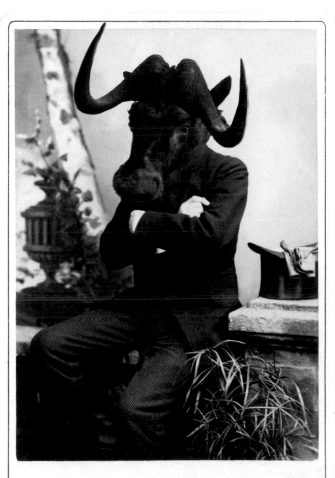

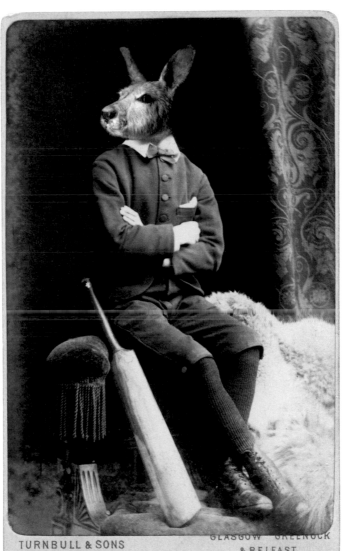

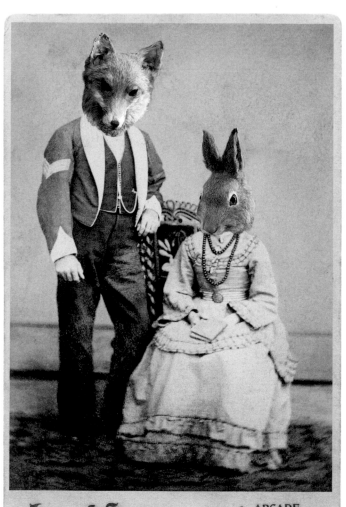

Lugg & Sons,

3. ARCADE
OKEHAMPTON.

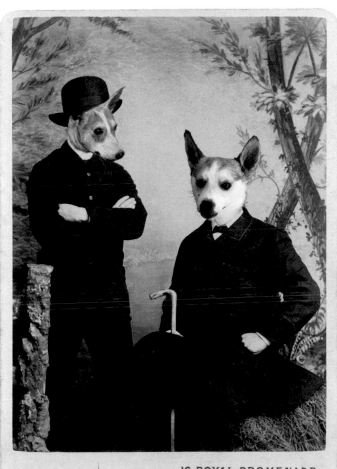

Allen.

16, ROYAL PROMENADE,
CLIFTON, BRISTOL,

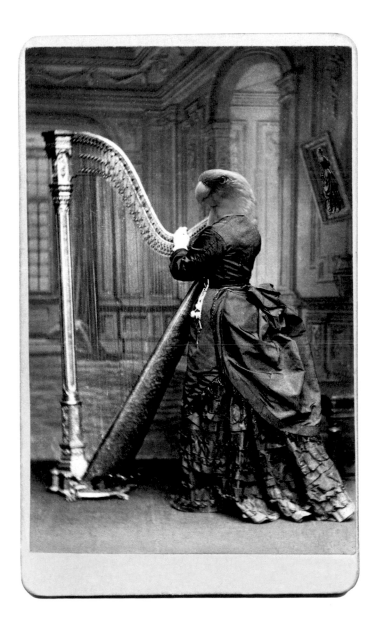

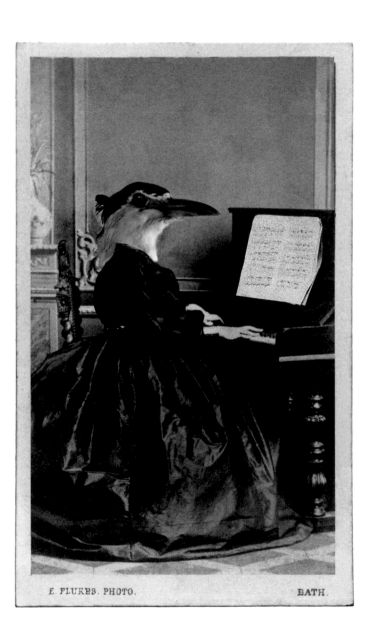

E. FLUKES. PHOTO. BATH.

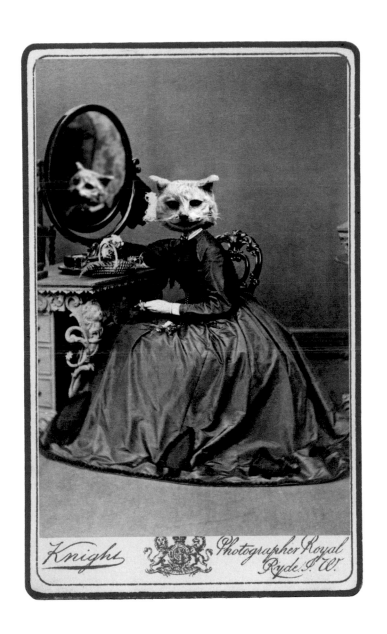

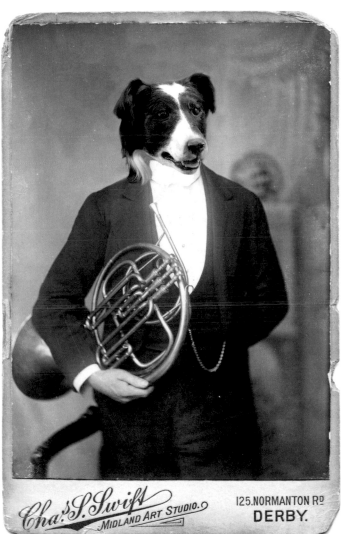

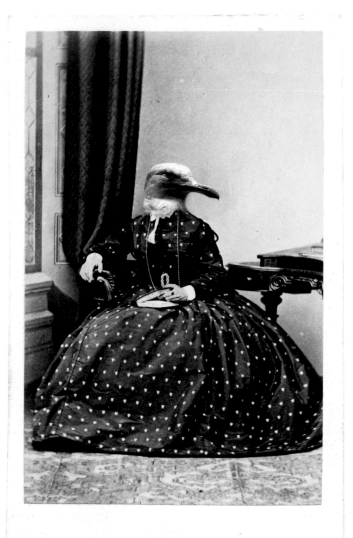

Hennah & Kent, Brighton.

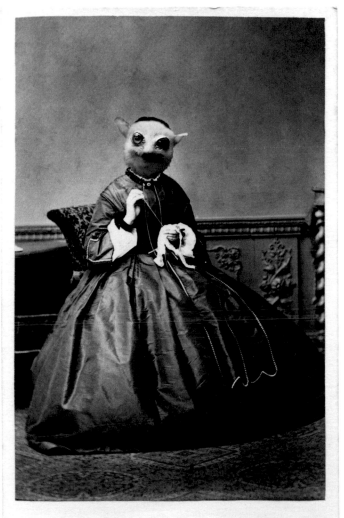

CONSTANTINE JENNINGS, TUNBRIDGE WELLS.

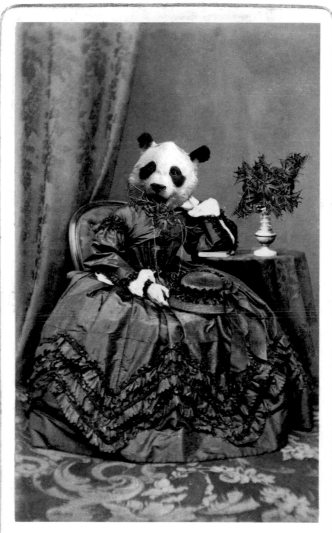

Horace G. Pike LICHFIELD.

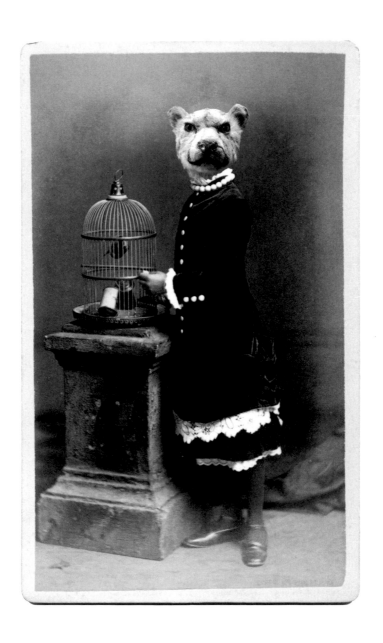

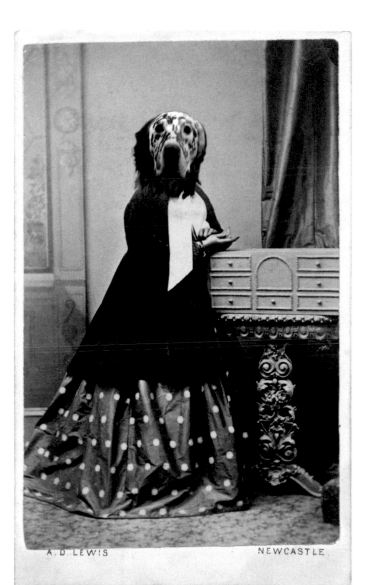

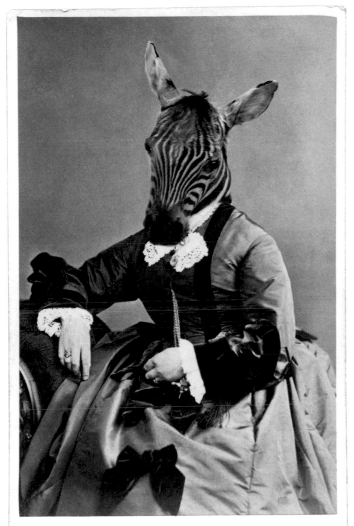

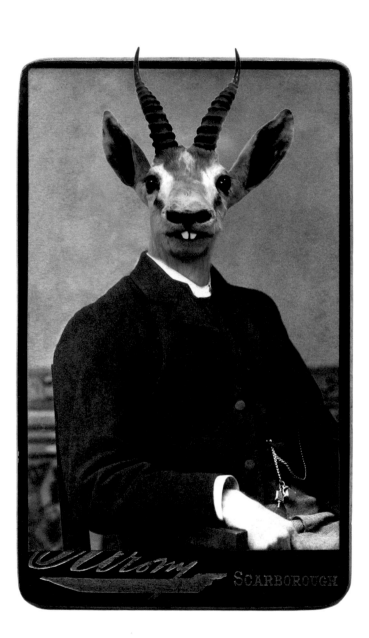

SCARBOROUGH

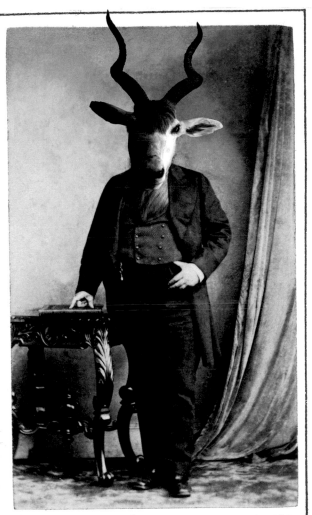

STEVENSON, TODMORDEN.

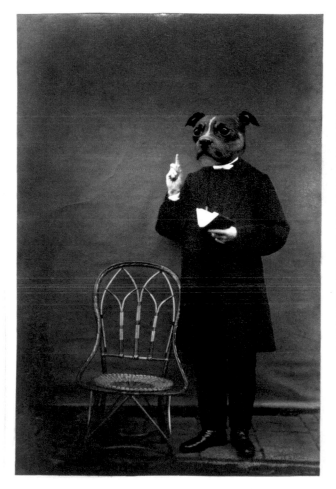

T. & J. HOLROYD. HARROGATE.

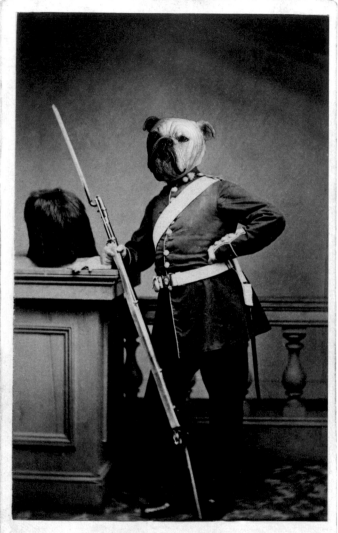

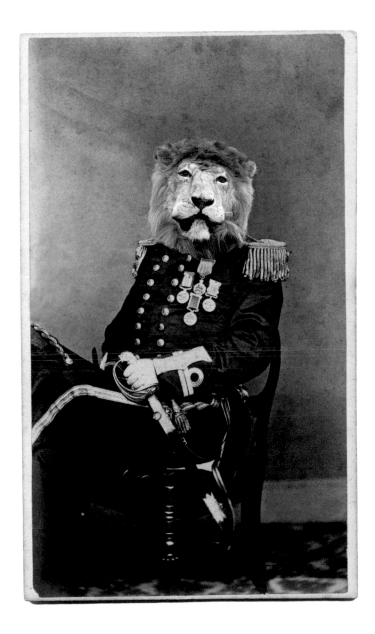

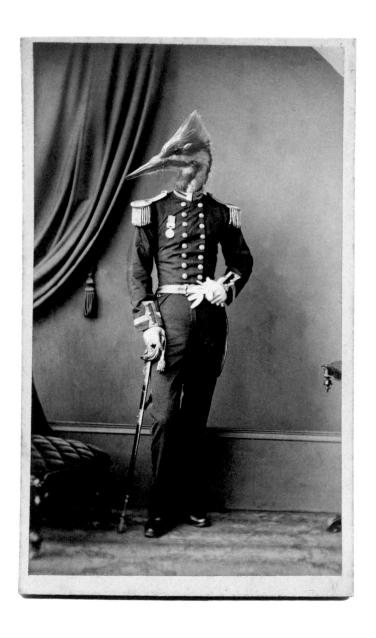

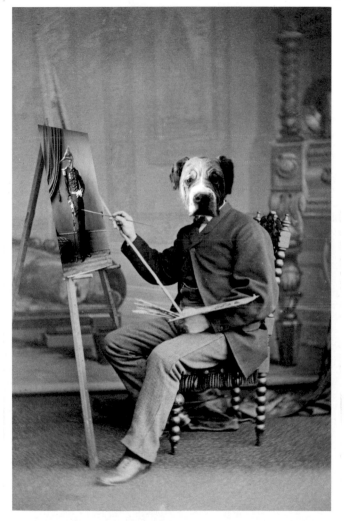

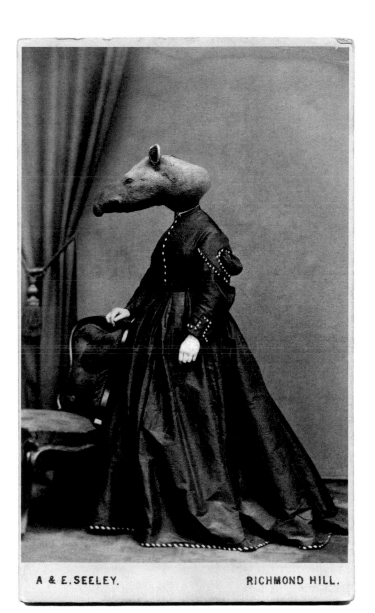

A & E. SEELEY. RICHMOND HILL.

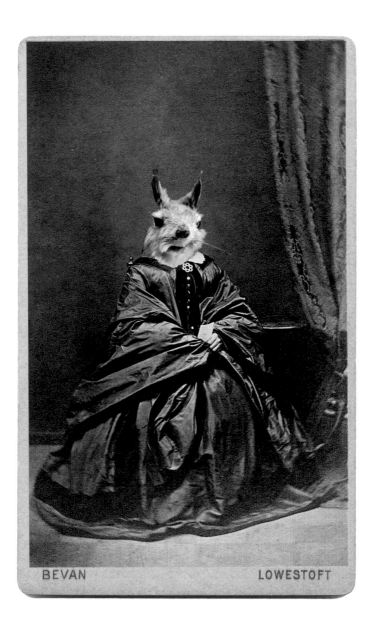

BEVAN LOWESTOFT

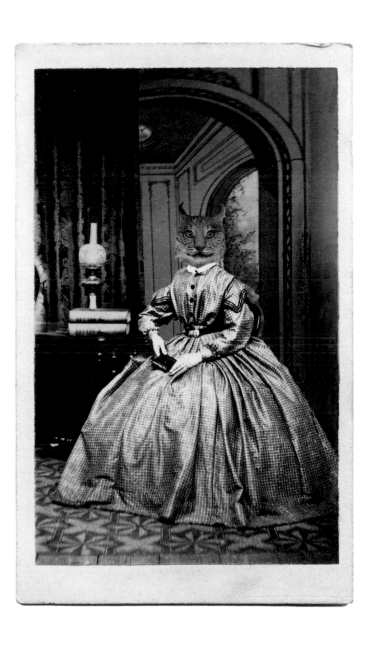

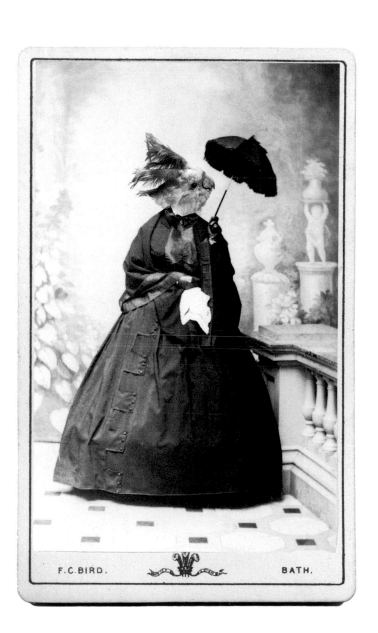

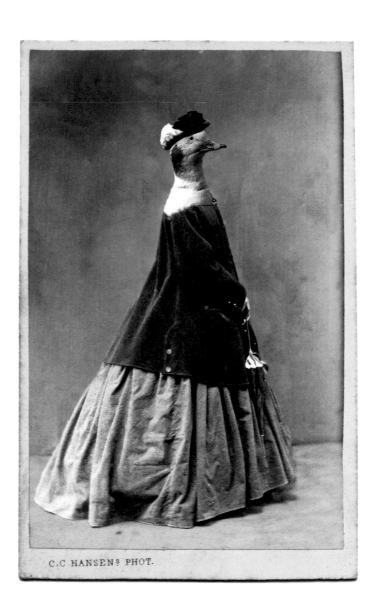

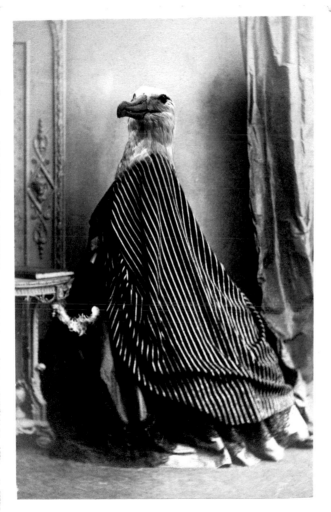

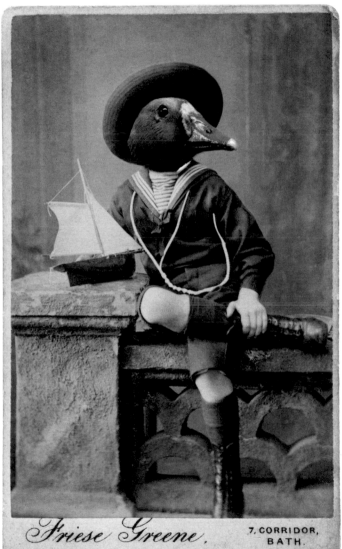

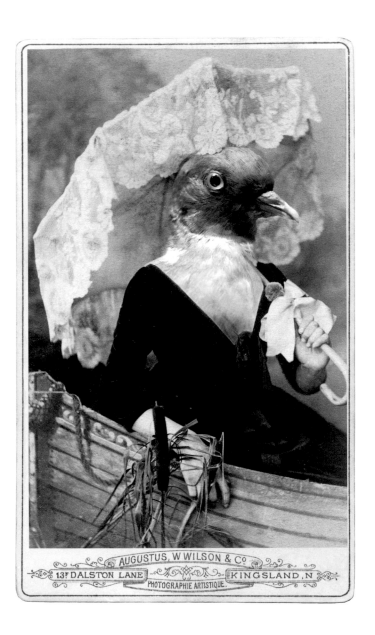

AUGUSTUS, W WILSON & Cº
13ᴵ DALSTON LANE · KINGSLAND, N
PHOTOGRAPHIE ARTISTIQUE.

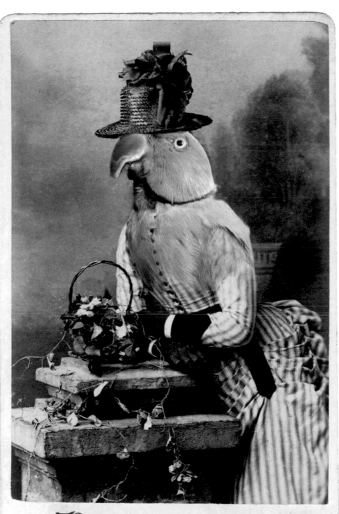

Porter

NEW ROAD,
CHIPPENHAM.

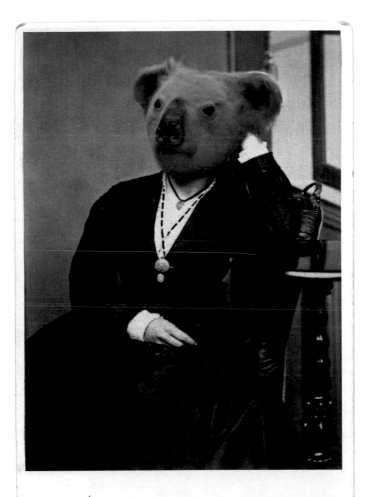

Hammer & Co. 172, RUNDLE STREET,
ADELAIDE.

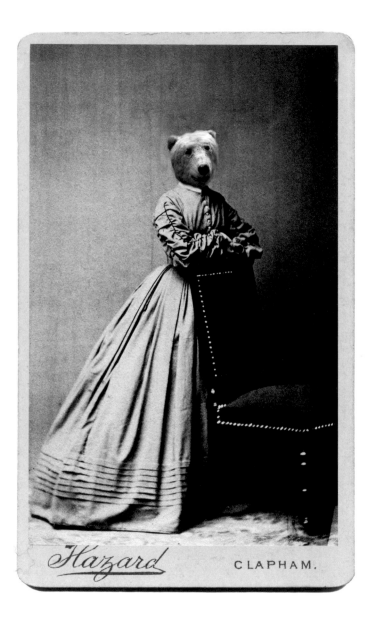

Hazard CLAPHAM.

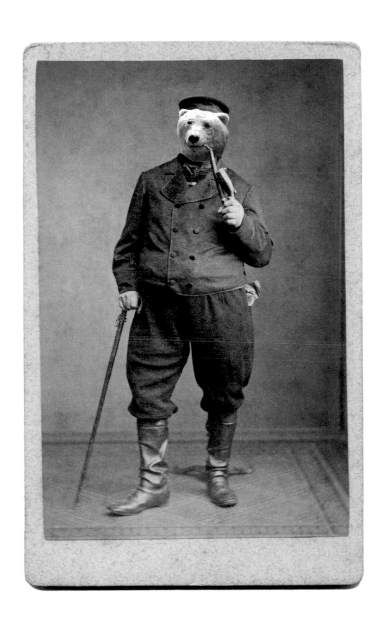

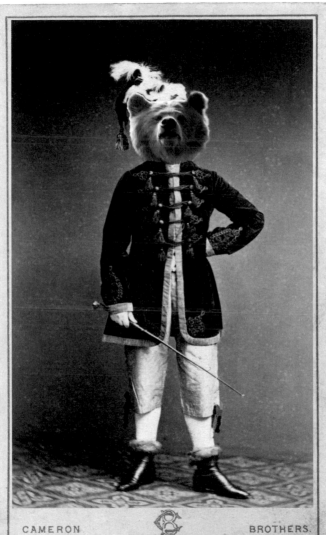

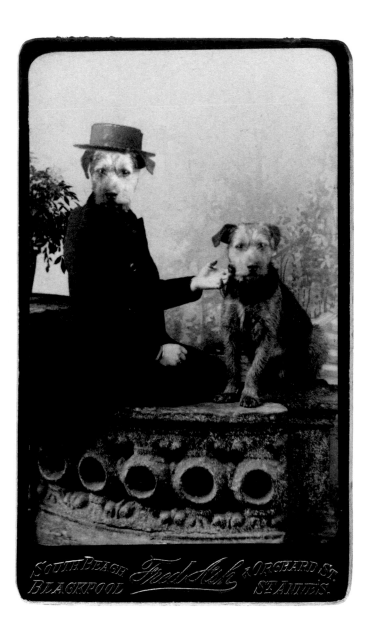

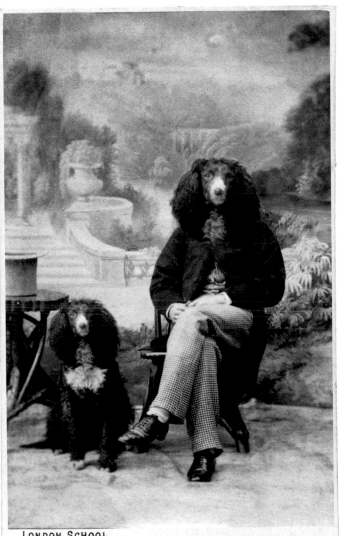

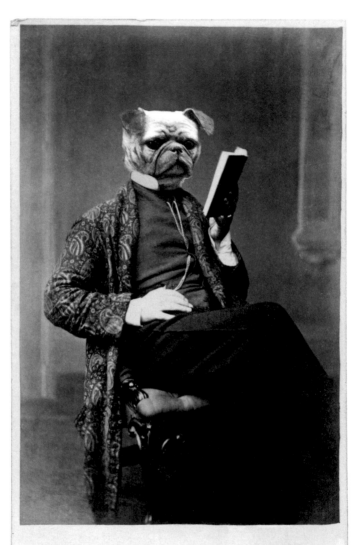

SCOTT CARLISLE

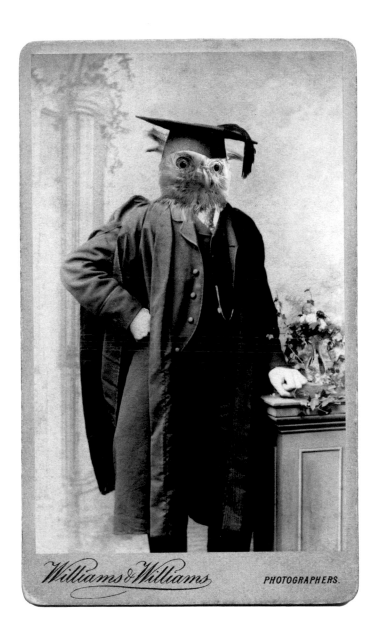

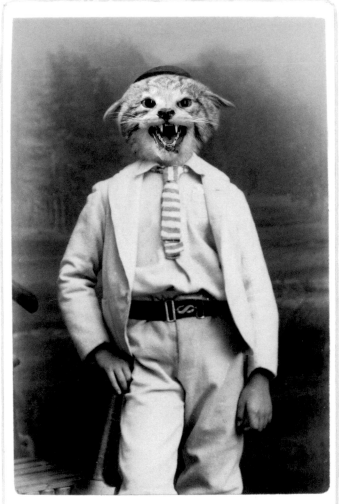

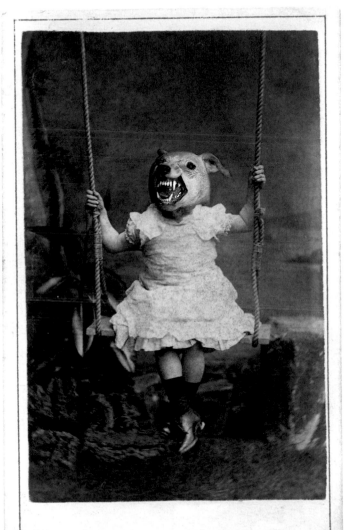

E. LOTT. NOLTON STUDIO.

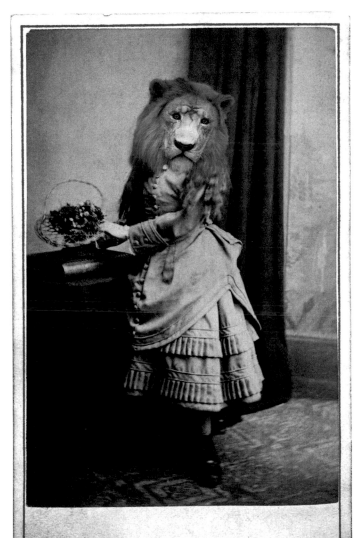

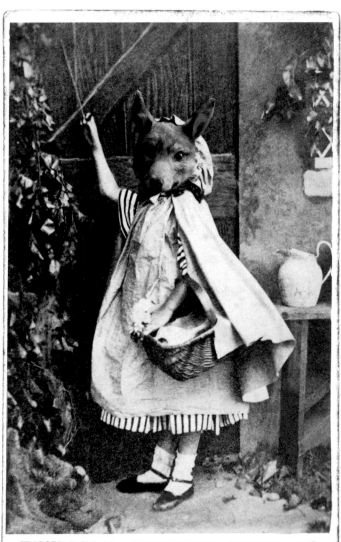

HENDREY'S IMPERIAL PORTRAIT.

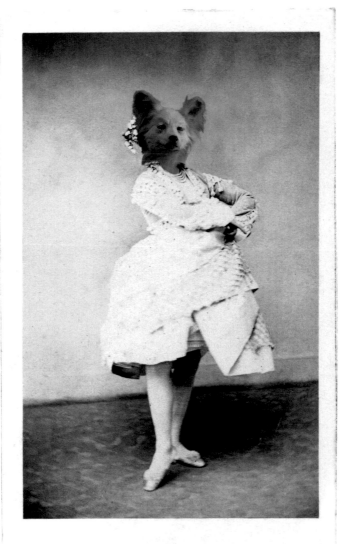

Franck Phot.

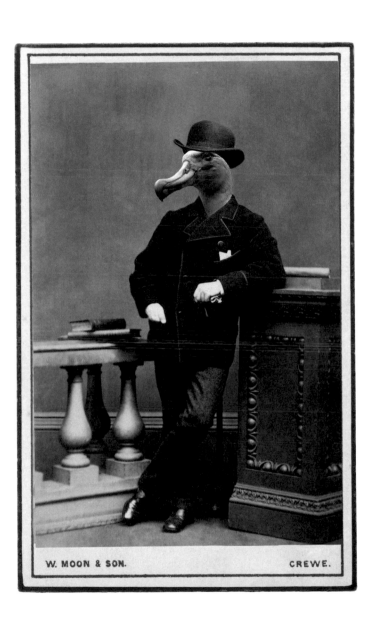

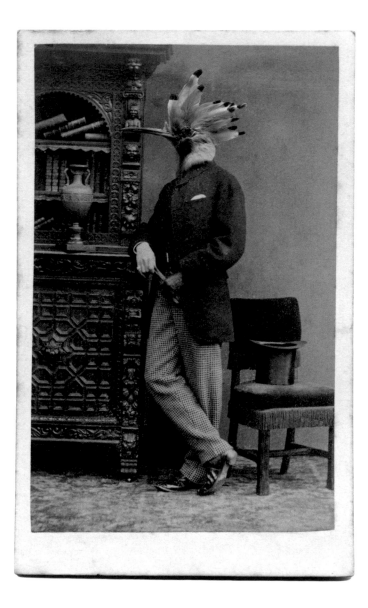

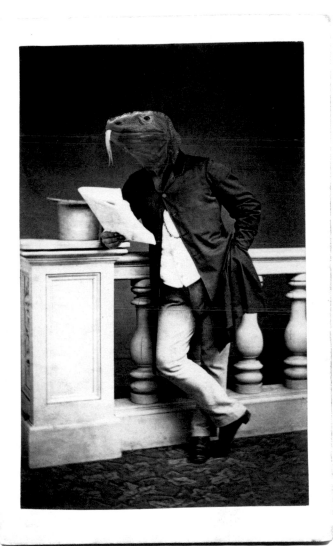

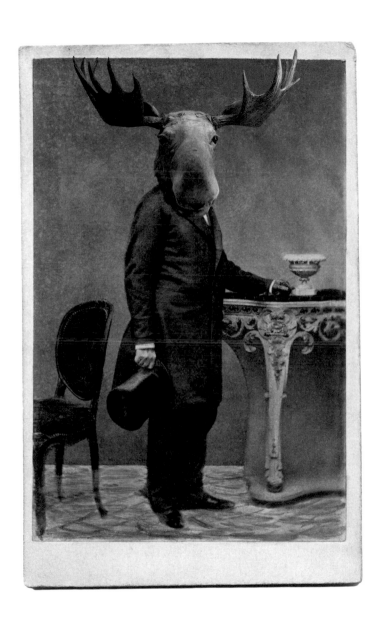

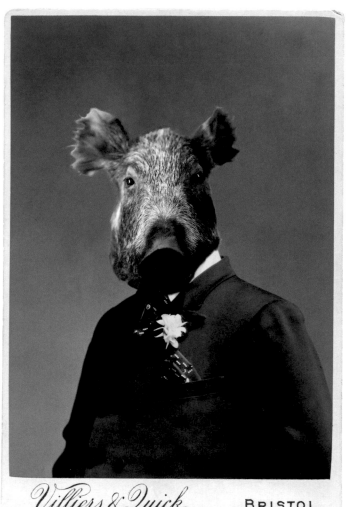

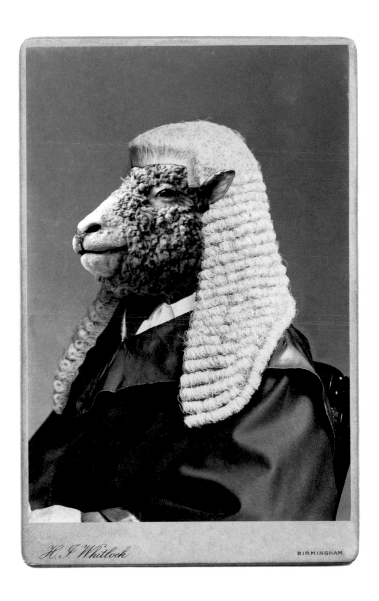

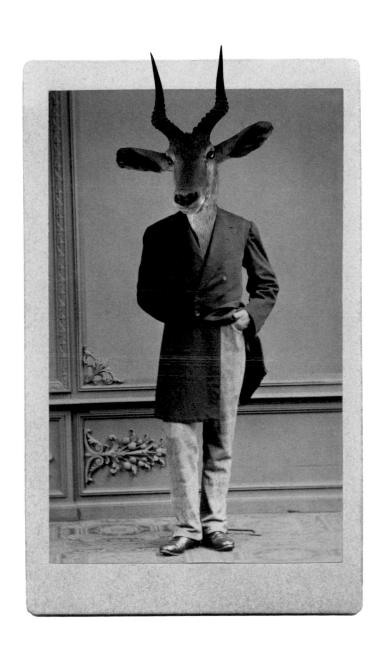

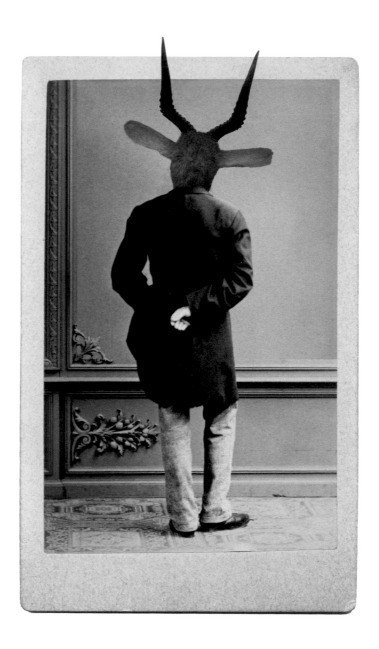